MEDIEVAL BIS
PALACE, LIN

LINCOLNSHIRE

Glyn Coppack BA PhD FSA

Inspector of Ancient Monuments

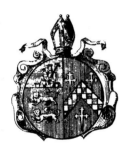

The once impressive palace of the medieval bishops of Lincoln lies on the crest of the ridge of the upper town, in the shadow of their great cathedral. Here the powerful bishops could entertain in state or administer their huge diocese. Much of the site was left in ruins after damage caused during the Civil War. Today visitors can see the remains of the halls, kitchen and bishop's apartments, and what may be the most northerly vineyard in England. This guidebook describes the characters, lives and building work of the different bishops and recreates how the palace may have appeared during medieval times.

❖ CONTENTS ❖

Published by English Heritage
23 Savile Row, London W1S 2ET
www.english-heritage.org.uk
© English Heritage 2000
First published by English Heritage 2000
This edition first published 2002, reprinted 2006

Photographs, unless otherwise stated, were taken by English Heritage Photographic Unit and
remain the copyright of English Heritage (Photographic Library; tel: 020 7973 3338)

Edited by Lorimer Poultney
Page layout by Hardlines, Charlbury
Artwork by Philip Winton (p.6), Hardlines (p.5, inside back cover)
Printed in England by the colourhouse

ISBN 1 85074 757 1
LP C40 05/06 08063

INTRODUCTION

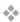

The palace at Lincoln was one of the most impressive buildings of medieval England, reflecting the power and wealth of Lincoln's bishops. It is situated on a spectacular hillside site, in the shadow of the cathedral, providing extensive views over the city.

Brayford Pool and Lincoln Cathedral, 1858 by John Wilson Carmichael

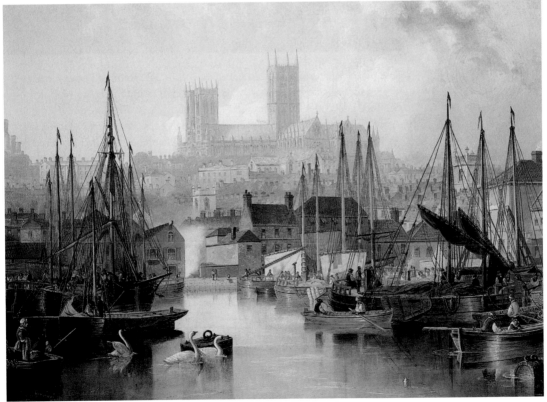

The bishop's palace, with a view of the cathedral in the background

The palace lies outside the cathedral close, but was, and remains an enclosed space of 1.05 ha between the close and the east wall of the city. To the south are the Victorian Temple Gardens, and to the west is St Michael's Church and churchyard. This position has given the site an aura of quiet and privacy, even though it lies at the heart of the city. Today it comprises the late nineteenth-century bishop's palace and its gardens, which contain the ruins of the central buildings of the twelfth- to seventeenth-century palace.

Lincoln was a major Roman city, and by the early fourth century had its own bishop. St Paulinus had built a church there in 627, and in 675 the bishopric of Lindsey was established, possibly centred on the city.

In 1067, Rémi of Fécamp, the first bishop created after the Norman conquest of 1066, moved the cathedral of his diocese from Dorchester-on-Thames to Lincoln to complement the castle that was being built within the ruins of the Roman town on top of the limestone ridge. From the first, the castle and cathedral were designed as symbols of Norman power, to express the authority of the crown and church on a conquered nation.

Subsequent bishops seemed to have lived outside the city, or within the royal castle, as land for a palace of their own was not granted until 1135. Even then, it was not until the mid-twelfth century that Bishop Robert de Chesney started to build a residence for himself and his household on the present site.

❖ WHAT DID BISHOPS DO? ❖

Medieval bishops were primarily administrators, responsible for overseeing and inspecting the clergy in their diocese. They would ordain new priests, supervise the election of abbots and priors of monasteries within their diocese, make 'visitations' or inspections of monasteries and other church establishments, and impose orders from their superiors. Bishops were also in charge of the justice administered in church courts, under the control of the bishop's chancellor.

All this required constant travel around the diocese. In addition, bishops had to supervise the running of their manors and estates. Some bishops also combined their church duties with service to the monarch in jobs such as lord chancellor or treasurer. This required them to attend court and travel with the monarch.

When appointed, bishops received extensive estates to support them and their large households of officials and servants, the remainder of the diocese's income supporting its clergy. The bishops of Lincoln presided over the largest diocese in medieval England, stretching from the Humber to the Thames. In addition to the palace in Lincoln, the bishop's principal manors in Lincolnshire were at Stow, Louth and Sleaford; in Nottinghamshire at Newark; in Rutland at Lyddington; in Huntingdon at Buckden; in Oxfordshire at Banbury; and in Buckinghamshire at Bishop's Wooburn. All these manors were to develop into major residences for the bishops from the early twelfth century.

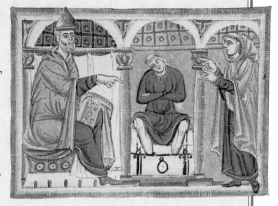

Top: A medieval illustration of a monk in the stocks being lectured to by his bishop. Bishops were in charge of clerical discipline, while church courts covered a wide variety of crimes, especially involving moral cases, such as adultery.

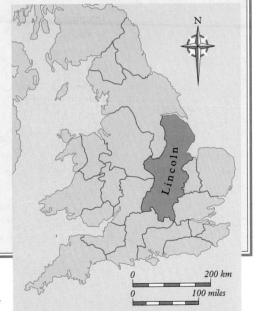

N

Lincoln

0 200 km
0 100 miles

The medieval dioceses of England and Wales

TOUR AND DESCRIPTION

*Bird's-eye view by
Philip Winton*

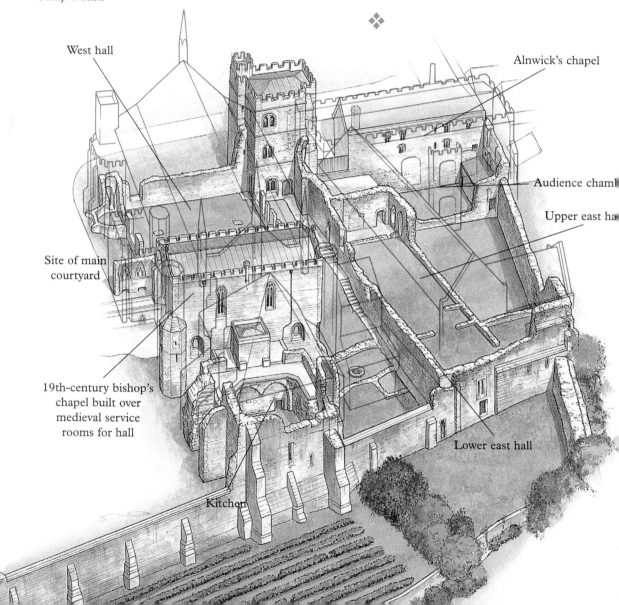

West hall

Alnwick's chapel

Audience chamb[er]

Upper east ha[ll]

Site of main
courtyard

19th-century bishop's
chapel built over
medieval service
rooms for hall

Lower east hall

Kitchen

Use this bird's-eye view of the medieval palace ruins to help guide you around the site. The outlines of the original buildings have been added in red to help you visualise the original appearance of this terraced site on several levels.

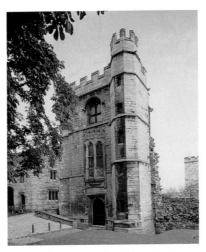

The Alnwick Tower, the entrance tower to Bishop Alnwick's private apartments

ENTRANCE TOWER

The palace was originally approached from Christ's Hospital Terrace to the west and from the cathedral close to the east. The main western entrance was blocked before 1848. Originally it led to a great courtyard in front of the west hall. The entrance to the ruins today is the private entrance to the later medieval private apartments.

This tower, built in the 1430s by Bishop Alnwick, linked his private rooms in the east hall range with the public west hall. The vaulted ground floor was a lobby between the west hall and the bishop's chapel. All three surviving doors are medieval, and that on the north side is decorated with Alnwick's coat-of-arms, a black cross on a white background.

The tower contains two rooms, reached by a stair from the west hall. On the first floor was the bishop's privy chamber (or bedroom) with an oriel window looking out towards the cathedral and a fireplace in the wall opposite. The blocked door to the left of the fireplace led to a short passage, off which was a latrine, to the bishop's pew at the west end of his private chapel. The room on the upper floor of the tower, also with a wall fireplace, was probably for the bishop's chaplain. A short passage from the stair led to the parapet gutter of the west hall, and in this passage is a drawing of a late medieval ship in sail.

The tower was substantially restored in 1876 by Bishop Wilberforce to provide lecture rooms for his Theological College. If you look closely you can see that parts of the building have been scorched red by a fire, apparently that of 1648. *Go from the tower down the steps. The twelfth-century east hall is on your left, and the early thirteenth-century west hall is on your right. Between them is a small, steeply sloping yard that contained Bishop Alnwick's privy kitchen and pastry and a well. Go through the door into the basement of the east hall.*

Oriel window in the first-floor room

❖ BISHOPS' PALACES ❖

In medieval terms, the word 'palace' showed that the bishop's residence was not simply a house but the centre of administration for his diocese, in much the same way as royal palaces contained the great offices of state. The palace was at the same time both private and public: the home of the bishop and his extensive household, and the place where the bishop entertained and held court. Its buildings were designed to impress and reflect the dignity and authority of a prince of the church. Not all bishops' houses were palaces; some were private, where the bishop could withdraw and relax, and these were called 'manors'. The house close to the cathedral was always called a palace. The other houses changed their function as different bishops decided which they preferred to use.

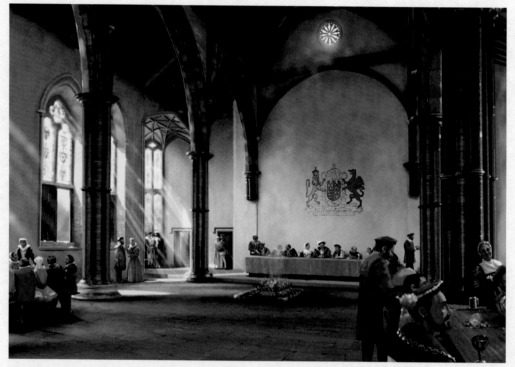

Reconstruction drawing by Peter Urmston of the interior of the west hall as it may have appeared during the great feast held by Bishop Longland in 1541 to entertain Henry VIII and Catherine Howard (see page 21)

LOWER EAST HALL

Twelfth-century bishops' houses were two stories high, with the bishop's hall and chamber at first-floor level and those of his household below. At Lincoln, the ground floor of St Hugh's house, built between 1186 and 1200, survives virtually intact, although later changes in ground level around it and the blocking of windows mean that it now appears more like a basement.

The rooms at the south end follow the same plan on both floors: a large chamber, with the wardrobe (literally the room where clothes were kept) and a very elaborate latrine or garderobe beyond that. The latrine was actually re-used from Robert de Chesney's buildings (which explains why its door is halfway up the wall).

The hall itself is through the door on the left, five bays long and originally with tall lancet windows. Those on the west were blocked in the late thirteenth century (a fireplace was introduced at the centre of the west wall in the early fourteenth century), and those on the east were partly

St Hugh's lower east hall. The well is at the far end

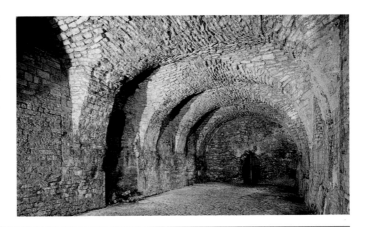

❖ BISHOP ST HUGH ❖

Hugh of Avalon was born *c*.1135 and around 1160 entered the cloistered world of the charterhouse of Grande Chartreuse as a Carthusian monk. He rose to be bursar of the house, and at the request of Henry II was appointed the third prior of his charterhouse of Witham in Somerset in 1175. An able administrator,

Hugh was responsible for the effective refoundation of the house and the development of its community. One of Henry II's most trusted advisers, he was appointed bishop of Lincoln in 1186.

At first sight, Hugh's appointment is surprising, but must be connected with the disaster that had overtaken

Lincoln in 1185. An earthquake had devastated the cathedral, bringing down the high stone vaults built by Bishop Alexander, and it was Hugh's skill as an administrator and builder that led to his appointment. He remained a committed Carthusian monk until his death in 1200 and was canonised in 1220.

blocked when the courtyard level on that side was raised. The hall had doors in both side walls at its south end; on the left a fifteenth-century rebuilding included a stair from the kitchen courtyard, on the right a spiral stair led up to the bishop's hall on the floor above. At the far end of the hall is a well. This part of the east hall range began to go out of use from the early fourteenth century, and by Bishop Alnwick's day it was used largely for storage.

LOWER TERRACE

Leave the east hall range through the modern opening (that removed a window) in its south wall. This brings you onto the lower terrace with its garden, vineyard and spectacular views over the city. In 1329, Bishop Henry Burghersh acquired land on the south side of the palace from the city to create a garden.

The south wall of the kitchen block seen from the modern vineyard in the terrace below

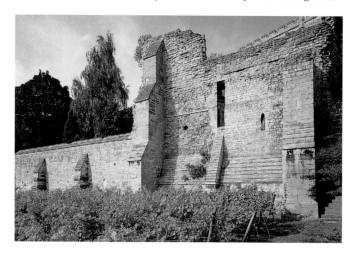

The previous year he had been granted the section of the town wall to the east, which is still standing to full height, and had incorporated it into the boundary of the palace which he was 'crenellating' or making defensive. The early fourteenth century was a troubled time for the clergy and Burghersh had also built a defensive wall around the cathedral close.

Burghersh's garden has not survived; what you see today is a reconstruction of the late nineteenth century when this area was the kitchen garden of Bishop King's palace. The western part is a vineyard maintained by Lincoln City Council; the eastern part is the contemporary heritage garden (see inside back cover).

The back wall of the terrace from the town wall on the right to just beyond the medieval kitchen on the left is largely the surviving south wall of Robert de Chesney's palace of the 1150s, retained when St Hugh rebuilt it in the 1190s.

Return through the square-headed door in the terrace wall which brings you up to the kitchen courtyard.

KITCHEN

St Hugh planned his new palace to have two hall ranges, one for his private use, and one for public use. While his private east hall range was relatively modest, his public west hall was on a vast scale, and only partially complete at his death in 1200.

The kitchen to provide the food for this hall still stands almost to full height, above an 'undercroft' (or basement) to bring it up to the same floor level as the hall itself.

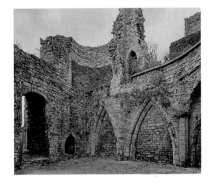

Bishop Hugh had almost certainly completed it, plus the ground floor of the service end of the west hall and the bridge that linked the two buildings, before his death.

The kitchen's external walls were decorated with blank arcades. Windows were set within the two western arches and the single one on the east side, and the undercroft was entered through a door at the centre of its north wall. Externally, this door is very grand, because the undercroft lay on the south side of the passage that led into the great courtyard to the west of the hall. The south wall was re-used from Robert de Chesney's palace and retains two of his lancet windows.

Apart from the vault, which was replaced in the 1220s, the undercroft remains substantially intact. Its original use is unknown but it was later the brewhouse and this may have been its original function. The kitchen above had five huge fireplaces: three in its corners can still be identified by their tile linings. They would have been used for roasting and for boiling cauldrons for the large meals required for feast days.

When Hugh of Wells completed St Hugh's west hall he found that the kitchen floor was almost a metre below the level of the hall. He rectified this by rebuilding the undercroft vault higher, carrying it on two pillars (which no longer survive). This higher ceiling allowed a tall lancet window to be inserted in the centre of the south wall, but externally the new vault required heavy buttresses which cut across the elegant arcading destroying its effect.

Inside the kitchen undercroft, with one of the tiled-backed fireplaces in the corner of the upper floor

Reconstruction drawing by Philip Corke of the great kitchen at the bishop of Winchester's palace at Wolvesey

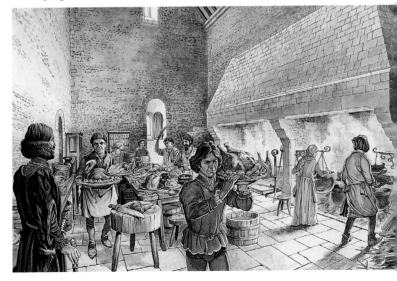

The kitchen was further altered by William Alnwick in the 1430s. He blocked the entrance beneath the bridge and cut a new door to the east. He built a massive staircase against the east wall, and strengthened the buttresses supporting the south and west walls which were evidently slipping down the hillside.

St Hugh also built the lowest part of the west hall service rooms, carrying them on an elegant undercroft which was entered from the courtyard to the west (this room is accessible from the garden of Edward King House). Simply a storeroom built to bring up the level of the lower terrace, the undercroft has an elaborate door because it too could be seen from the public area of the palace.

Return up the steps along the side of the east hall, the remains of a gallery built in the late thirteenth century, and go through the door on your right.

UPPER EAST HALL

St Hugh's upper east hall, chamber and wardrobe have almost entirely disappeared. The doorway to the hall, with its twin shafts and 'stiff-leaf' capitals, remains, but of the upper east hall itself only the northern end survives above floor level. From these fragments we can tell that the hall was of exceptional quality, its internal walls decorated with arcaded recesses in which the doors and windows were set. A lost door in the east wall led to a spiral stair to the lower hall (see page 10). The lack of a wall fireplace indicates a central hearth.

At the far end, with extensive views over the city, was the bishop's great chamber where he conducted his private business. Two doors in its east wall led to the wardrobe and from there to the latrine in the latrine tower retained from Chesney's earlier palace.

By the fifteenth century, great nobles such as bishops wanted more private accommodation than could be provided by the earlier open hall and great chamber. When Bishop Alnwick moved his private chamber to his new tower in the 1430s, he also modernised and refitted the upper east hall, chamber and wardrobe to create more contained accommodation for both himself and his growing household of officials. The unscreened lower end of the hall was given a masonry screen wall with a pair of doors opening into a new dining room for the bishop, slightly longer than the old hall. The survey of the palace in 1647 tells us that a floor was inserted over this room to provide 'garrets', or attic rooms, for the bishop's household.

The great chamber was shortened to become a private or lesser hall, and was similarly floored over, and at the south-west corner a spiral stair was added to lead down to the kitchen courtyard and up to the garrets. The wardrobe became the bishop's study. The surviving brackets on the east

wall show that these rooms were only
2.5m from floor to ceiling.

ALNWICK'S CHAPEL RANGE

*Return to the north end of the hall and
go through the right-hand door in the
end wall. You are now in the
chapel range.*

Bishop Alnwick's chapel range,
contemporary with his entrance tower,
was a remarkable building. Its layout
may appear confusing at first, because
it was terraced into the hillside, so the
first floor is in fact at ground level out-
side the palace. On the first floor to
the east was the bishop's chapel where
the bishop could hear mass performed
by his chaplain. On the floor below
was an audience chamber and private
oratory. An ante-chapel, with the bish-
op's private pew above it, occupied
the western part of the first floor.
Underneath on the ground floor were
vaulted storerooms.

The principal room on the ground
floor was the bishop's audience
chamber, described as the 'parlour'
in 1647, entered from the east hall.
The room was lit from the south by
three windows, including a centrally
placed oriel which looked out over a
small courtyard. You can also see the
site of a fireplace in its north wall
towards the eastern end. In the west
wall, between the two doors, is an
elaborate 'buffet' or sideboard.

The door you can see in the north
wall leads to a latrine, while the door

*Looking down the length of
the site of the upper east
hall towards the bishop's
great chamber that would
have been at the far end*

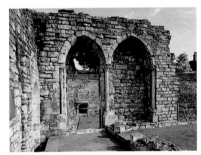

*The surviving walls of the
upper east hall*

next to it in the west wall leads to a
series of vaulted chambers. The first is
a lobby, long known as the 'treasury',
lit by a square window high in its
north wall. A low, narrow door leads
to a strongroom. The westernmost
chamber was a storeroom, entered
from the lower end of the hall.

At the other end of the audience
chamber is Alnwick's private oratory
(small chapel), where the bishop
could pray in private. It is covered by
a curved barrel vault and lit by a single
window in its south wall. The stone
floor and altar below the window have
disappeared, but otherwise the room is
complete, with a piscina (for washing
the communion vessels), cupboards in
the west, north and east walls, and
lamp brackets.

Left: Charles Mainwaring's early nineteenth-century coach-house, with the remains of Alnwick's chapel range in front of it

Right: The stone sideboard in Bishop Alnwick's audience chamber

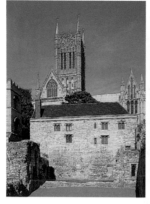

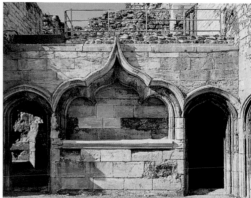

Engraving of the palace by Samuel Buck, 1726, shortly before the demolition of the house created from Alnwick's chapel range by Col Berry

Return to the east hall and go up the spiral stair though the left-hand door in the north wall.

On the first floor, the ante-chapel was lit in its north wall by two windows, of which a fragment of the western one survives. A badly damaged fireplace in the south wall shows that the room was heated, and a recess for a holy water stoup was provided at the centre of the west wall. No trace

remains of the screen that separated this area from the chapel proper, and only a fragment of moulded cornice in the south wall indicates the level of the bishop's 'withdrawing chamber and pew' that originally lay above it. The pew was entered from the first-floor chamber in the tower and by the spiral stair in its south-west corner.

Of the chapel itself only the ruins of its east end survive. To either side

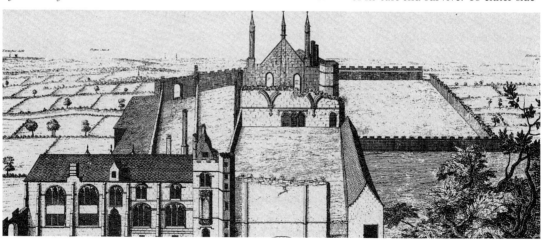

of the east window are blocked niches that once contained statues. Below the window and flanking the site of the altar are two cupboards that once had doors. A third cupboard was placed in the east bay of the north wall. The chapel was lit by three windows in its north side, and four windows in its south wall. Gervase Holles noted before 1642 that the chapel windows contained glass with verses invoking the protection of the Trinity for William Alnwick, his arms, and his motto *Delectare in Domino* (Delight in the Lord).

The chapel and tower were converted into a house by Colonel James Berry, one of Oliver Cromwell's 'majors-general', who acquired the ruins of the palace in about 1652. Slight alterations of this period survive, including the blocking of the east window of the chapel, but the house was demolished in 1726 when Bishop Reynolds gave the dean and chapter permission to take stone from the palace. Alnwick's excellent masonry was too tempting and it was the chapel that provided stone for the cathedral masons.

WEST HALL

From the ante-chapel, go through the door into the entrance tower. Go through the door in the wall opposite and enter the west hall.

Begun by St Hugh and completed by Hugh of Wells, the west hall was the public and ceremonial centre of the palace. It is perhaps the earliest in a series of ground-floor halls which were to dominate bishop's palaces in England. Here the bishop could present his public face at audiences, entertain in style on feast days and receive important visitors.

The west hall was a grand and impressive building: the piers and arcades were of contrasting black 'Purbeck marble' and there were paired windows, again detailed in Purbeck. At the north end of the hall the bishop would have sat on a raised platform or 'dais'.

Heating was provided by an open hearth, placed in the centre of the hall. At the opposite end was a wooden screen, beyond which was the main entrance through an elaborate moulded door decorated with 'stiff-leaf' capitals.

The 'service' end of the hall has three doors. The wider central door led across the bridge to the kitchen, the doors to either side to the pantry and buttery where bread and wine and beer were stored. A blocked door in the south-west corner of the hall led to a spiral stair which led to the bishop's great chamber above. (This part of the building was altered in the 1880s to create a chapel for the new bishop's palace, changing the roofline of the building which originally was roofed the same as the hall. It is not accessible to the public.)

The west hall, with the Victorian bishop's chapel behind, seen from the door to the upper east hall

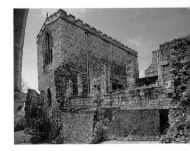

The interior of the west hall, looking towards the now-blocked three service doors at the far end

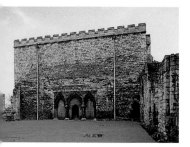

Bishop Grosseteste added an elaborate two-storey porch to the entrance door from the main courtyard of the palace. Only its ground floor survives, although the 1647 survey describes an upper room. The details on the porch are similar to work in the cathedral completed by 1239, particularly the galilee porch on the south transept.

The west hall remained unaltered until Bishop Alnwick added a bay window to the dais end, looking out over the great court and balancing Grosseteste's porch. A spiral stair near this window led to a latrine and a gallery running along the north wall of the west hall to a door high up in Alnwick's entrance tower.

After the Civil War Col Berry converted the ruins of the hall into a paddock, reducing the height of its walls and blocking the doors and windows. The porch became his coach-house, and he built a stable along the length of the west wall, removing Alnwick's impressive bay window. The gap in the north wall marks the site of the gate into the paddock.

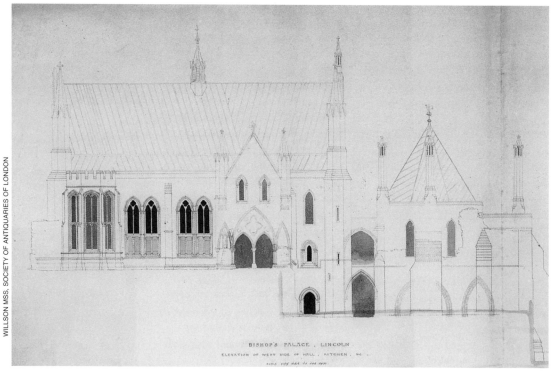

BISHOP'S PALACE, LINCOLN.
ELEVATION OF WEST SIDE OF HALL, KITCHEN, &c.

HISTORY

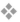

EARLY BUILDINGS

Sometime before 1133 Bishop
Alexander had been given the Roman
east gate to the north-east of the new
cathedral to act as his residence, but
perhaps found it too close to the
castle, the seat of royal power in the
city. In 1135-38, he was granted a
new site by King Stephen: 'between St
Michael's church and the city ditch as
the ditch reaches to the city wall, and
round the said church, land of the
king's demesne . . . Further, the king
grants to the bishop in the same place
the actual ditch and city wall to make
a way of ingress for himself and to do
what is convenient for his building'.
This grant describes the site of the
palace and its access from the west,
now Christ's Hospital Terrace. While
Alexander began the clearance of the

❖ BISHOP ROBERT DE CHESNEY ❖

Chesney was archdeacon of
Leicester prior to his
appointment as bishop of
Lincoln in 1148. Of a mild dis-
position, he is generally credited
with weakening the see by the
alienation of its estates and by
exempting St Albans Abbey
from the bishop's control. He
was the first builder of the
Bishop's Palace in Lincoln after
1155 and bought a London
house for the see in 1162. He
notoriously pledged the cathe-
dral jewels to Aaron the Jew of
Lincoln, but was also the cleric
who urged Archbishop Becket
to submit to Henry II in 1164.

*Opposite bottom: A mid nineteenth-
century reconstruction by Edward
Wilson of how the west hall and
kitchen block may have appeared at
the end of the fifteenth century, seen
from the west from what was the
great courtyard of the palace*

The palace site seen from the air, with the cathedral at the top and vicar's court on the right

A capable bishop was needed to restore Lincoln's fortunes. Henry II's choice was a man he had personally brought to England to establish his Carthusian monastery of Witham in Somerset: Hugh of Avalon. Hugh was appointed in 1186, the only Carthusian monk ever to become an English bishop. His time in Lincoln was marked by two major building campaigns: the total rebuilding of the bishop's palace, and the rebuilding of the eastern arm of the damaged cathedral. Both were out of character with his Carthusian background but were intended from the first to mark his authority as a reforming bishop. His biographer, Gerald of Wales, recorded that he began to build 'splendid episcopal buildings, and he intended, with God willing, to complete them in a grander and more magnificent style than the earlier ones'. On his death in 1200, only the east hall range had been completed, though work on the west hall range had begun.

There was then another pause in construction work, as the see was left vacant for three years before the appointment of William of Blois. William spent only three years in Lincoln, and it was not until 1209 that King John appointed Hugh of Wells. Bishop Hugh immediately fell out of favour for taking Archbishop Langton's side in John's quarrels with the pope, and was forced into exile until 1213. Reconciled with the king,

site and appears to have completed the access road, the instability caused by the civil war between the supporters of Stephen and the Empress Matilda seems to have halted any further work. He was, in any case, busy elsewhere, rebuilding his castles of Newark, Sleaford and Banbury during these troubled times. It was not until 1155–58 that Bishop Robert de Chesney had the site regranted by Henry II and began building a new palace that was largely complete by 1163.

St Hugh's Rebuilding

After Bishop Chesney's death in 1166, the see was left vacant for many years, and it was during this vacancy that disaster struck Lincoln when an earthquake destroyed the greater part of the cathedral and perhaps the palace.

Hugh then supported Prince Louis of France who was offered the crown on John's death in 1215 against the young Henry III. Louis invaded England and it was at Lincoln that he was finally defeated in 1217 while besieging the castle. Hugh only retained his bishopric on payment of a large fine. In these circumstances, it is hardly surprising that work did not begin again at the palace until the 1220s. In 1223, Hugh of Wells was permitted 'to dig and take stone in the ditch of the city near his house for the building of his house at Lincoln' and, in the following year, 40 great oaks were supplied from the royal forest of Sherwood for the roofing of his hall.

As well as his work at the palace, Hugh completed St Hugh's choir and transept and began the rebuilding of the cathedral nave. He also built the chapter house and is the first recorded builder of the palace at Buckden. He died in 1235 to be succeeded by Robert Grosseteste, who had been closely associated with him in his reform of the diocese. A strict disciplinarian, within a year Grosseteste had quarrelled with the cathedral chapter and had summarily deposed eleven heads of religious houses in his diocese. He was deeply concerned with pastoral care within his diocese, something reflected in his support of the friars. He completed the nave of the cathedral, rebuilt Hugh of Wells' central tower which had collapsed in

1237–39, and built the galilee porch – the bishop's ceremonial entrance from the palace. He died in 1253, and would have been canonised but for his constant preaching against papal abuses and his refusal to induct the pope's nephew to a Lincoln canonry.

THE PALACE IN THE FOURTEENTH AND FIFTEENTH CENTURIES

The next documented work at the palace began in 1329 when Bishop Henry Burghersh obtained a licence to fortify the palace and acquired the terrace on its south side. It was probably Burghersh who built the new gatehouse on the east side of the palace leading from the newly enclosed Cathedral Close, and who built the lodging range along the western boundary of the site that today forms the core of Edward King House. Burghersh was a prolific builder, responsible for remodelling and crenellating the palaces of Lyddington, Nettleham and Stow, and rebuilding the river front of Newark Castle.

The bishop's palace then remained little changed until the second quarter of the fifteenth century when Bishop William Alnwick (1436–49) brought its buildings up-to-date. Alnwick, who had been a prolific builder as bishop of Norwich, was responsible for building the new gatehouse tower at the north end of the east and west

The porch to the west hall, added by Bishop Grosseteste

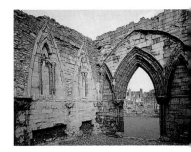

❖ BISHOP HENRY BURGHERSH ❖

Born in 1292, Burghersh was trained to be a royal administrator. Originally proposed for the see of Winchester in 1319, he was imposed on Lincoln the following year, but was soon caught up in the power struggle between Edward II and Queen Isabella.

On Isabella's return from France in 1326 he openly supported her and was appointed commissioner to obtain Edward II's abdication the following year. Under Isabella's patronage, he was appointed lord treasurer in 1327, and lord chancellor in 1328-30.

Recorded as being 'destitute of political morality', he was temporarily imprisoned in 1330 when Edward III seized control from Isabella and her lover, Roger Mortimer, but was soon back in royal favour and was reappointed lord treasurer in 1334. A trusted royal servant, he was employed by Edward III in Flanders in 1338 and 1340, where he died.

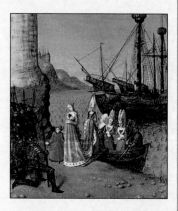

Queen Isabella lands in Suffolk in 1326. Burghersh joined her shortly afterwards.

Medieval floor tiles in Alnwick's audience chamber (now covered to protect them)

halls that still bears his name and a chapel and audience chamber range at the north end of the chapel courtyard designed to provide an impressive approach to his private apartments from Burghersh's new gate.

This remodelling of the palace should be seen in the context of similar improvements in bishops' residences elsewhere. For example, Cardinal Beaufort was remodelling his Winchester palace of Wolvesey at precisely the same time and Bishop Waynflete began the similar updating of Farnham Castle from 1447. Alnwick was also responsible for substantial rebuilding work at

Sleaford, and carried out major works at Lyddington.

Between 1496 and 1514 Bishop William Smith built an outer east gate on the access road to the palace from the close, completing the development of the medieval palace.

DECLINE AND DESTRUCTION

The close association between Bishop John Longland and Henry VIII made the palace a prime target during the Lincolnshire Rising of 1536. Although the rebels entered it, the

❖ BISHOP WILLIAM ALNWICK ❖

William Alnwick became archdeacon of Salisbury in 1420, and a prebendary of York in 1421. In 1426 he became bishop of Norwich, royal patronage becoming apparent with his appointment as confessor to Henry VI. He was translated to Lincoln in 1436 where he had to settle a violent dispute

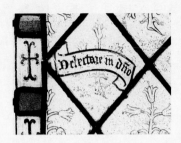

William Alnwick's coat-of-arms and motto in painted glass from the former bishop's palace at Lyddington

between the dean and chapter.

In 1440 he published a new code of statutes for the regulation of the cathedral that started a power struggle between him and the dean that was still unresolved at his death in 1449. He was closely involved in the foundation of Eton College and King's College, Cambridge.

extent of the damage is unknown. Whatever it was, repairs must have been carried out by 1541 when Henry VIII and Queen Catherine Howard were entertained in the palace (when one of the alleged indiscretions that led to the queen's execution took place). Early in the reign of Edward VI, Bishop Henry Holbeech was forced to surrender thirty-four 'manors' to Protector Somerset acting on behalf of the crown. Only the palaces of Lincoln and Buckden and the manor of Nettleham remained in the bishop's possession. Nettleham, the smallest, was best suited to the bishop's reduced means, and Holbeech died there in 1551. After that it would appear that the Lincoln palace was little used.

In March 1617, James I visited Lincoln for nine days and was entertained to a banquet in the palace after a service in the cathedral on 31 March. It is significant, however, that the king and his party were lodged elsewhere. Bishop John Williams started repairs to the palace in 1625-28, in part using materials from Nettleham which by then had been abandoned. These repairs and additions, which were to include a library, continued throughout the 1630s, even though Bishop Williams resided principally at Buckden. The work was never finished, however, the repairs being overtaken by the onset of the Civil War.

In 1643, while the castle at Lincoln was being refortified, the High Sheriff was instructed to remove prisoners from the castle to the palace which became a temporary prison. Captain Hotham removed the lead from the roof of the kitchen, presum-

ably for casting shot, and Alderman Emas helped himself to the lead down-pipes and spouts. In the following year, the city fell to Parliamentary forces, and though there was destruction within the close, the palace appears to have escaped serious damage.

In 1647, Parliamentary Commissioners made a survey of the buildings with a view to the disposal of the site. The Long Parliament had abolished the church hierarchy the previous year, and as there was no bishop there was no

longer any need for a palace. The survey reveals that, with the exception of the lead that had been removed, the buildings were generally in good order and of some considerable value. In June 1648, however, a Royalist raiding party entered Lincoln and the thirty-strong Parliamentary garrison retreated into the palace. The Royalists stormed the site and in the ensuing action its buildings were fired. The extent of the damage is uncertain, but stripping of roof lead and demolition continued for some time afterwards.

Engraving by Hieronymus Grimm of the west hall porch, service rooms and kitchen as they appeared in 1809, viewed from where the Victorian bishop's palace now stands

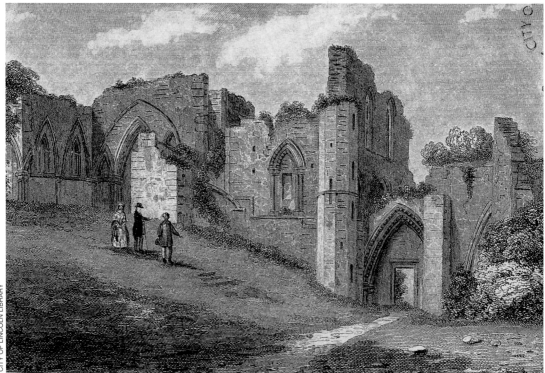

In 1652, Col James Berry bought the site of the palace and converted at least some of its surviving buildings into a reasonably modest house. On the western boundary of the site, the fourteenth-century lodging range remained intact. Bishop Sanderson recovered the palace at the Restoration of Charles II in 1660, but the buildings were regarded as beyond economic repair and were abandoned in favour of Buckden, an alternative house being provided for the bishop when he was in Lincoln.

DECAY AND PRESERVATION

In 1726, Bishop Richard Reynolds licensed the dean and chapter to take stone from the palace site for the repair of the cathedral, only reserving the western lodging range occupied by his clerk Dr Debia and Berry's stables and coach-house which he intended to remodel as a house for himself and future bishops. In the following year, however, the palace site was leased to Dr Edward Nelthorpe for 21 years. Nelthorpe began the rebuilding of the surviving range of lodgings, and was followed by Mrs Elizabeth Amcotts in 1738, who completed the conversion of the medieval lodgings into a respectable Georgian residence. The ruins became a feature of its gardens.

In 1838, Charles Mainwaring leased the palace and began a substantial programme of clearance and repair. He added the stables and a coach-house on the north side of the old chapel range and rebuilt the inner east gate to the north of Alnwick's private apartments which had been in poor repair since 1821. Edward Willson, a noted antiquary and the city surveyor, undertook a detailed survey of the medieval palace ruins during Mainwaring's tenancy and may have been responsible for some if not all of the repairs.

THE RESURRECTION OF THE BISHOP'S PALACE

In 1840, the diocese of Lincoln was reduced in size, with the removal of the counties of Bedford, Buckingham, Hertford, Huntingdon and Leicester. The bishop's principal residence was moved from Buckden to Riseholme in 1841, and the remaining lease on the palace site was bought back by Bishop John Kaye. The bishop's registrar immediately took up residence there. Bishop Wordsworth (1869–85) decided that Riseholme was not a convenient residence and decided to sell the house and return to the close.

His plans were not immediately achievable, but in 1876 Alnwick's tower was restored to provide lecture rooms for the Theological College he founded in Lincoln. It was his successor, Bishop Edward King, who oversaw the move back to the palace site. Riseholme was finally sold and in 1886–88 Nelthorpe's house was

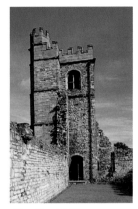

The Alnwick Tower was carefully restored in the nineteenth century to match its original appearance

remodelled and extended by Ewan Christian to provide a suitable residence. In a second phase of work the chamber block of the west hall range was rebuilt by Bodley and Garner as a new bishop's chapel.

By 1945 the palace was regarded as too large for the bishop's requirements and his residence moved to Atherstone Place. The Victorian palace became the diocesan offices, and a conference and retreat centre, now called Edward King House. The ruined elements of the Medieval Bishops' Palace were placed in the guardianship of the Ministry of Works in 1954 and have been repaired and conserved for public display.

FURTHER READING

Medieval bishops' palaces have recently been described and analysed generally by Michael Thompson in *Medieval Bishops' Houses in England and Wales* (Ashgate, Aldershot, 1998). For the Medieval Bishops' Palace in Lincoln, see Patrick Faulkner, 'Lincoln Old Bishop's Palace' in the *Archaelogical Journal* 131 (1974), 140–4.

❖ BISHOP EDWARD KING ❖

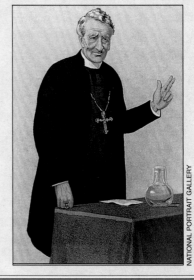

King was born in 1829 and educated at Oriel College, Oxford, where he was influenced by the Tractarian movement. He was chaplain of Cuddesdon Theological College from 1858 to 1863, and principal of the college and vicar of Cuddesdon from 1863. In 1873 he was appointed professor of pastoral theology at Oxford and a canon of Christ Church, where he strongly influenced religious life in the city. He was appointed bishop of Lincoln in 1885. A High Churchman, he taught real objective presence and practised confession – something that resulted in his prosecution for illegal religious practices in 1889. The trial enhanced his popularity in the diocese, and the archbishop of Canterbury found largely in his favour, a verdict which was upheld on appeal. He died in 1910.

Detail of a cartoon of Bishop King by 'Spy', from September 1890, during his trial before the archbishop

NATIONAL PORTRAIT GALLERY